The Autochromes of J.H. Lartigue

The Autochromes

of J. H. Lartigue 1912-1927

Translated by Brian Coe

Ash & Grant

Ash & Grant
9 Henrietta Street
Covent Garden
London WC2

'Ash & Grant' is a registered imprint of
Dorling Kindersley Ltd
All rights reserved
First published in the United Kingdom
by Ash & Grant 1981
Translation copyright © Brian W. Coe 1981
Originally published in France by
Éditions Herscher, Paris, 1980.

British Library Cataloguing in Publication Data
Lartigue, J.H.
 The autochromes of J.H. Lartigue.
 1. Lartigue, J.H. 2. Photographers–France–
 Biography
 I. Title II. Les autochromes de J.H. Lartigue.
 English
 770'.92'4 TR130.L32
ISBN 0-904069-45-1 ✓

Printed in Switzerland

A CONVERSATION
WITH J. H. LARTIGUE
ABOUT HIS AUTOCHROMES

Georges Herscher*: When a publisher is given the chance to publish a book of Jacques-Henri Lartigue's autochromes, and, furthermore, when sixty years after the autochromes were made he can interview the photographer, who is in good health, clear-eyed, and has a good memory, he is not going to let the chance slip by.

From the autochrome plates that are still in existence we have selected thirty images for this book. Their dates range between 1912 and 1927. Let's remind ourselves that you took your first photograph at the age of seven, in 1901, and that the Lumière brothers introduced their "autochrome" process in 1907.

I am not going to bother you with technical details; we will ask a specialist to provide them.

Jacques-Henri Lartigue: That's fine. Besides, I don't know anything about them!

G.H.: How and when did you hear about this invention?

J.H.L.: It was probably around 1911 that I heard about it, and since I had been looking forward to the possibility of working in color, I grabbed the chance.

G.H.: So you had been waiting for this technical breakthrough?

* Georges Herscher is the director of Éditions Herscher in Paris, the French publisher of this book.

J.H.L.: Yes indeed. Even when I was a small boy I was itching for it to happen. Because, for me, life and color cannot be separated from one another; it had to happen.

G.H.: What equipment did you use?

J.H.L.: It was very simple. I used the same camera that I always used for black-and-white, a Nettel 6 × 13cm "stereo." It had two lenses, which I fitted with yellow filters, and I could load the camera with six plate holders of color plates that I bought from Lumière. Each plate had a small black mount on its back.

G.H.: I would think that the shooting was complicated: setting up the tripod, the black cloth, the long exposure. . . . Didn't this discourage you—you who are known for your love of life and action, and hence of action shots?

J.H.L.: I didn't need a black cloth, but a tripod was necessary because the big problem was the long exposure time, and that bored me. That's why I did relatively little color photography at that time.

G.H.: How did you figure out the length of exposure and the focus?

J.H.L.: It was easy for me, since I was used to gauging distances and I worked by rule of thumb. Exposure time was four or five seconds and didn't change much with the weather or the time of day. The advantage of less sensitive plates is that the tolerance of error is much bigger.

G.H.: Who developed the photographs?

J.H.L.: I entrusted them to a special laboratory in Paris where the plates were mounted as stereo pairs, which is to say that the two photographs were transposed.

G.H.: Was this impression of depth—which unfortunately can't be seen in book reproductions—important to you?

J.H.L.: Very important. When you look at the photos in a stereoscope, and at that time all my black-and-white photos were in stereo as well, you get an extraordinary effect.

G.H.: Why did you decide in certain instances to take a photo in color rather than in black-and-white? Didn't you always have two cameras at your disposal to give you the choice of one or the other?

J.H.L.: No, I always used the same camera. In fact, I would have liked to have taken all my photos in color, and in certain instances—a beautiful garden, for example—it seemed a must, but the long exposure time precluded it.

G.H.: The choice of whether to photograph in black-and-white or color is an ancient and constantly recurring subject among people who talk about photography, and I don't need to remind you of the obsessions about it. Our friend Henri Cartier-Bresson, among others, is a diehard and insists that color belongs to the painters. What do you think?

J.H.L.: I think that monochrome photography is a form of interpreting reality, but as nature is full of color, color photography should be the norm. The black-and-white process can give very beautiful results, just as there are admirable black-and-white drawings, but color is the truth.

G.H.: But then how do you explain the fact that many people consider color a kind of anomaly and want it to remain the exception?

J.H.L.: There is undoubtedly a tradition that favors black-and-white. Besides, in certain instances—and it is true for movies and television—monochrome images can have more impact in comparison with color images, which might appear wishy-washy or toned down.

G.H.: You have always been a painter as well as a photographer, and I want to ask you, were you ever torn between painting and photography when you wanted to reproduce a landscape or a person?

J.H.L.: I have always been a painter. Therefore I see everything with my painter's eye. But I need several hours to make a painting, and as I travel a lot, thousands of tempting landscapes pass by. I have tried to console my painter's eye by taking color photos that require only two minutes of my time.

G.H.: Just now we established that autochromes, unlike monochrome photographs, didn't work with action shots. But from this point of view they had a big advantage over painting. Another question on the painting/photography comparison. Some painters use photographs in preparing their paintings—David Hockney and Jacques Monory are two such contemporary artists. What do you think of that?

J.H.L.: Of course I have tried it. But it is the emotional combination of scents, of silence, that makes me paint with passion; when I paint out of doors, it's the feeling of making love with nature. Photography has a mechanical side that doesn't inspire me in the same way; I can use it like a paintbrush or a bit of paper, but that's all.

G.H.: We must come to the problem of the aging of autochromes. The colors of the plates we see now are unfortunately not the original tones. The originals have deteriorated unevenly, depending on whether and how long they may have been exposed to heat or light. It is very irritating not to be able to see what you have tried to do, although it was visible once.

J.H.L.: It leaves me heartbroken!

G.H.: Really—isn't the word too strong?

J.H.L.: Not at all. I wanted to preserve the things that excited me, and when I saw that my records were spoiled, I was in despair. Sometimes the results of these changes are pretty, but it is no longer the truth.

G.H.: When we reproduce these records in book form, starting with what we have now, can't we profit from what we might be able to do during the platemaking process before going to press in order to try and correct the colors a little, following your guidelines?

J.H.L.: I think we can, if we stick to corrections that can be made very carefully and delicately.

G.H.: I have heard you use the word "truth" twice. What is its meaning for you?

J.H.L.: It's the reproduction, without distortion, of what in real life registered with me. I'm well aware that for others this truth could be different.

G.H.: I want to bring up a subject, and I hope that—knowing your legendary kindness—it won't upset you.

J.H.L.: No need to worry.

G.H.: Here is the question. In looking at your autochromes I am struck by a kind of frankness and simplicity in regard to your subjects. Gide said that one cannot make good literature with kindness. Many photographers seem to think that one cannot make beautiful photographs with beautiful subjects. But, looking at yours, especially the autochromes, it appears that your greatest pleasure has been to photograph pretty women in beautiful gardens or lovely sunsets. I'll go further—and please consider this a compliment—it seems to me that your autochromes have a touch of "kitsch," although it is deliberate and good kitsch. What do you think?

J.H.L.: It's all a problem of taste and the corruption of taste. An infant loves milk; as he grows up the child likes wholesome foods; but little by little, as he grows older, he comes to prefer overripe cheeses and well-hung game. In the end, one can prefer hell to heaven.

If you are passionately fond of the beauties of nature, you shouldn't be afraid of being ridiculed for wanting to represent them. For me, the only thing that counts is to be successful in "capturing" the things that excite me, and if I distort instead of capturing them, it's because I've not worked well.

G.H.: But you obviously prefer to photograph those subjects that you yourself find beautiful and pleasing rather than those that might appear more important to others.

J.H.L.: It's a matter of taste. I prefer to be happy and smiling than to be unhappy and whimpering.

G.H.: You must have noticed that fashion photographers—some of them good friends of yours—who have the opportunity to photograph the most beautiful women in the world in the most beautiful clothes go very far in different directions when they want to express themselves without inhibitions. I'm thinking, for example, of the photos taken by Richard Avedon of his father in the last years of his life. The pictures shown in New York were pretty terrifying. You never would have done that, obviously.

J.H.L.: The only thing that interests me is succeeding in what I want to do. One can find beauty in distressing and so-called ugly things, and certain painters and photographers have done it. Naturally, one can also make very bad and ridiculous work with subjects chosen for their ugliness.

This tendency to choose unpleasant subjects is part of the sickness of our times; it makes men pave their way to their purgatory. But there must be a reaction against it and a return to Beauty.

G.H.: If one could—and I use the conditional deliberately—offer a criticism of your view of life, it is that above all it appears to concern itself with a world privileged by fate and wealth. Nowadays one might be a little afraid of appearing to justify a certain kind of life-style.

J.H.L.: I must say that if I am rated that way, for the most part it is because journalists know only a small fraction of my work, and view it with blinkers and preconceived ideas.

For example, my photographs of children in shanty towns have nothing to do with my images that supposedly show the rich bourgeoisie. On the other hand, most of the beautiful things shown in my photographs didn't belong to me. I didn't even know the owner of the Château de La Garoupe and its magnificent gardens, but I went to paint there with the help of one of the many gardeners. At times when I lived on very little money, I used the cars or the yachts of my friends.

G.H.: After 1927, it seems that you didn't make any more autochromes. Was it because you had given up the process in favor of more modern ones?

J.H.L.: No, it was around 1950 that I began to take color photographs again. Until then, in spite of my love of color, I took only black-and-white, because I was discouraged by the impossibility of taking action pictures.

G.H.: Now, let's both look at the images that we have decided to reproduce. I'd like you to tell me what they evoke in you. It will be a strange experience, because I certainly imagine that when you took the photographs you didn't think they would become a book.

J.H.L.: Certainly not.

The first two images date from a trip to Pau in the winter of 1912. My parents had rented a villa with a large garden. (Photos 1 and 2)

In 1913 I had gone with my parents to Vichy, where Mama "took the cure." I played tennis, walked, and even then painted a lot. (Photos 3 and 4)

G.H.: Next we have chosen seven photos taken at Rouzat in the Auvergne, where your parents had a château with large grounds. We know from your monochrome photographs and your diaries that you had several marvelous vacations there with your family and friends. (Photos 5 through 11)

J.H.L.: We stayed there three months in summer and at Easter.

Here's the two-wheeled "bob" designed by me and built by my friend Mauve, an airplane builder. It overturned regularly on the curves. We used small airplane wheels both for it and the four-wheeled "bob," which was much less delicate and more solid; there was less risk of the wheels buckling on the curves. Here, I'm inflating a tire. (Photo 7)

In this picture Simone Roussel is working one of the two brakes on the same "bob"; these were wooden levers that dragged on the ground. (Photo 8)

Here, in front of the hangar, is the last of the airplanes built by my brother Zissou before the war. Like its predecessors, this airplane managed to take off a few times—an extraordinary thing at the time—but it usually broke on landing. (Photo 9)

Madame Charles Samuel, a friend of my parents. She was the wife of a Belgian sculptor who was famous at the time. (Photo 11)

Here I am at Chamonix with a group of skiers who were all more or less great tennis players. We were all staying at the same little hotel in Chamonix. (Photo 12)

I photographed myself in the snow mainly because of the orange sweater; I was very proud of it. Here, as in the previous photo, I used a self-timer. (Photo 13)

Sunset at Mouleaux, near Arcachon. (Photo 14)

Lilian Mur [right] was a ravishing young American and the darling of the habitués of the Bois de Boulogne, where I had the pleasure of meeting her every morning. At this time we knew very few Americans in Paris, and we all thought of them as cowboys. My mother used to say: "Don't bring her father

to our home, he could very well come with shoes but without socks." (Photo 15)

G.H.: In December 1919 you were married to Madeleine Messager, daugher of André Messager, the composer. From then on we see a lot of "Bibi" in your photos.

J.H.L.: In the spring of 1920 we lived with some relatives in Nice, then in the Hotel Cap d'Antibes, which was not yet as rich and snobbish as it later became. (Photos 16 and 17)

Here's a photo of the gardens of the Château de La Garoupe, which we talked about, and where I went to paint "illicitly." (Photo 17)

This photo was taken at the Hotel Cap d'Antibes, in the tearoom near the small rock swimming pool that was later christened the "Eden Roc." (Photo 18)

G.H.: It's a classic image in itself, and one can't help being reminded of Matisse's paintings of the same era and of the same places.

J.H.L.: As always, it was my taste that led me to the gardens and flowers that I painted. . . .

We went to the Côte d'Azur in May, when the tourists were few and far between. (Photos 19 through 23)

Rouzat in summer. I took backlit photographs, which at the time was rather unusual. (Photos 24 and 25)

Bibi in Paris. (Photos 26 and 27)

There we are at Cimiez, in the gorgeous garden of a convent where I went to paint. (Photo 28)

G.H.: The dress, the hat, the layout of the garden are all typical of the twenties.

J.H.L.: Even Bibi's pose!

A large deserted beach, as I like it, at Hendaye, where we went in the summer, after Rouzat. Tank suits were acceptable from then on. (Photo 29)

The Île de Saint-Honorat was still very wild at this time. (Photo 30)

Arlette Boucard at Cannes, in the superb house of her father, Dr. Boucard, who worked very hard but also lived well and loved to have fun. (Photo 31)

G.H.: I think that the last picture needs no comment. (Photo 32)

J.H.L.: It's a really nice idea to finish this way.

G.H.: Knowing you both, it seems to me that Florette, your wife of nearly forty years, and you provide the best ending to the book. Like the other books that we've done together, *The Autochromes of J. H. Lartigue* is a kind of handbook of happiness.

NOTES ON THE AUTOCHROME PLATES

Research into the chemical recording of colors and their faithful reproduction is bound up with the beginnings of the research that led to photography itself. One could even observe that it preceded black-and-white photography, which is only a chemical transformation of a representation of the real world, acceptable after the event.

As early as 1810 Thomas Johann Seebeck, a physicist in Jena, noted the property of silver chloride in recording certain parts of the spectrum. In 1848 Edmond Becquerel experimentally recorded spectral colors on the subchloride of silver. This process, improved by Claude Niepce de Saint-Victor, Alphonse Poitevin, and Saint-Florent, did not reach a practical application. Gabriel Lippmann also explored the technique of direct recording of color, and in 1891 he demonstrated the so-called interference method, whose elegance was matched only by its complexity.

The fundamental principles from which the first practical solution to the problem of color photography was born were based on the use of three colors (red, yellow, and blue). They were applied to photography for the first time by Louis Ducos du Hauron and, in theory only, by Charles Cros in 1869. All colors could be obtained by mixing red, yellow, and blue. The technique was therefore to record on sensitive plates the appropriate radiations, using filters to block the unwanted rays. Superimposition of three colored positives reconstituted the full color image. Surviving results show the quality obtained by Ducos du Hauron, but it was at the price of difficulties of manipulation incompatible with commercial application. As early as 1869 Ducos du Hauron suggested that the solution might lie in juxtaposing a large number of small color filters on a single plate. John Joly, of Dublin, was one of the first to attempt such a method, but it was the Lumière brothers who developed a satisfactory solution.

After research into improvements in the classical direct color and interference methods, on May 30, 1904, at the Academie des Sciences, the Lumière brothers presented a new process that enabled amateurs to work in color photography: autochrome. It took three years to bring manufacture from hand production to an industrial scale, and it was in 1907 that the new plates were officially announced to the public, in *l'Illustration* magazine.

The analyzing filters of autochrome were made from grains of potato starch less than ten to twelve millimeters in diameter. After these grains—which had been dyed orange, green, and violet—were thoroughly mixed, they were sprinkled on a glass plate coated with a sticky varnish. This produced a dispersion of from two to three thousand grains per square millimeter. The spaces between the grains were filled with carbon black, and then the plate was submitted to a pressure of five tons per square centimeter in a rolling mill. A varnish coating of the same refractive index as the grains followed, to protect the mosaic formed from being attacked by the products of development and fixing. Finally, a very thin coating of gelatin-silver bromide panchromatic emulsion was applied.

Beginning in 1907 the plates were on the market in the usual formats, up to 18 × 24cm. It was necessary to take certain precautions when using them. A filter had to be used in front of the lens to compensate for the lens' excessive sensitivity to blue and violet. The plate had to be exposed, and the ground-glass focusing screen reversed the image. To protect the emulsion against the risk of scratching, a piece of

black cardboard was placed between the plate and the back of the plate holder. Photographers were soon able to buy special metal plate holders altered to fit the autochrome.

However, the principal drawback of the autochrome was its insensitivity. The exposure time was fifty to sixty times longer than that of the blue label extrarapid plates produced by the same manufacturer. Under these conditions, action shots were impossible to take. Even in bright sunshine and with a landscape without a distracting foreground, the exposure went from around one-eightieth of a second at $f/6.8$ to around three-quarters of a second. Moreover, one had to have a Compound- or Koïlos-type shutter to control the exposure, and a tripod was needed.

Once the picture had been taken, one had to develop the autochrome plate oneself in a fairly short time, and this involved two development processes. The first operation produced a negative complementary image, the second a positive image by reversal. A final varnishing was supposed to brighten the colors and protect the sensitive coating. Altogether, the necessary operations took fifteen or twenty minutes of work.

In the case of stereoscopic views of the type used by J. H. Lartigue, yet another operation was needed to ensure a satisfactory effect of depth. If the transparent plate was viewed directly in a stereoscope, one got a good effect of relief, but once it was reversed, it produced a "pseudostereoscopic" effect. Distant objects came forward, and near objects receded. It was thus necessary to cut the plate in half and transpose the two images.

In spite of all these limitations, for almost thirty years autochrome was one of the few available solutions to the problem of the photographic reproduction of colors. One must wonder at the silence of the Lumière brothers regarding the uses of the "omnicolor" plate introduced by Ducos du Hauron and de Bercegol in June 1907. This plate was said to be able, when developed, to "reproduce all the colors in nature." True, it was manufactured by J. Jougla, of Joinville-le-Pont, and this rival was soon absorbed by . . . Lumière. Omnicolor, which lasted only a short time, was more sensitive than autochrome, but its color selectivity was inferior.

Up until the 1930s there was a burgeoning of screen plate processes; few gave satisfactory results. To quote from memory: Thales plates (with separate reseau—1908, then integral—1909); Dufay dioptichrome (made by Guilleminot-Boepsflug, with separate reseau—1909, then integral—1910, and improved—1912), whose density was weaker than autochrome; the German Agfacolor plate (1916); the Finlay process, the last on glass (1929). From memory, since the three-color screen processes were innumerable.

From the 1930s on, the popularity of flexible celluloid base led to new products by the Lumière brothers: Lumicolor and Filmcolor (1932 and 1938). In 1948 ultrarapid Filmcolor reached a useful speed of 17 degrees Scheiner. The autochrome principle appeared to still be workable. But in fact new processes had appeared that finally were to eliminate this kind of product. In 1935 Kodachrome film had been introduced in France. It represented a new technique, that of the integral tripack, which improved definition spectacularly. Because of the smaller-size cameras and the technical support of trade laboratories, a new mass market opened up for color photography.

Yves Aubry

1. Papa and Mama in Pau, winter 1912.

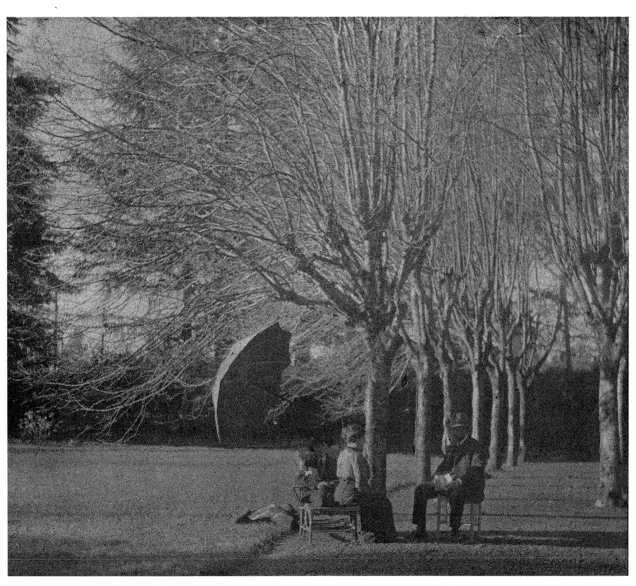

1

2. Near Pau, 1912.

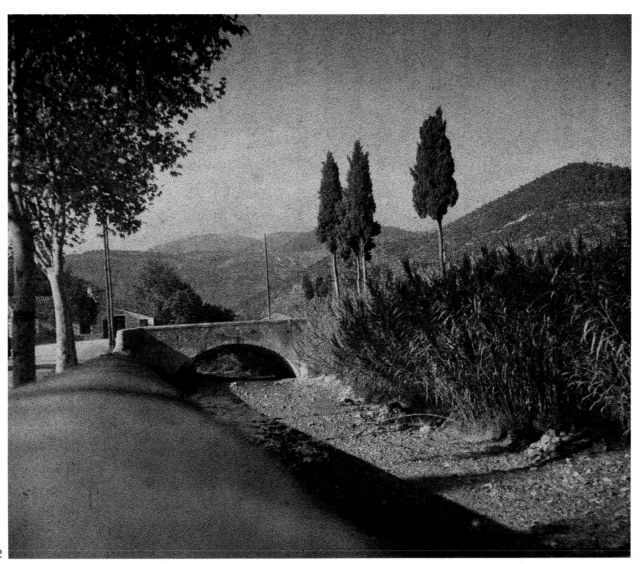

2

3. Vichy, 1912.

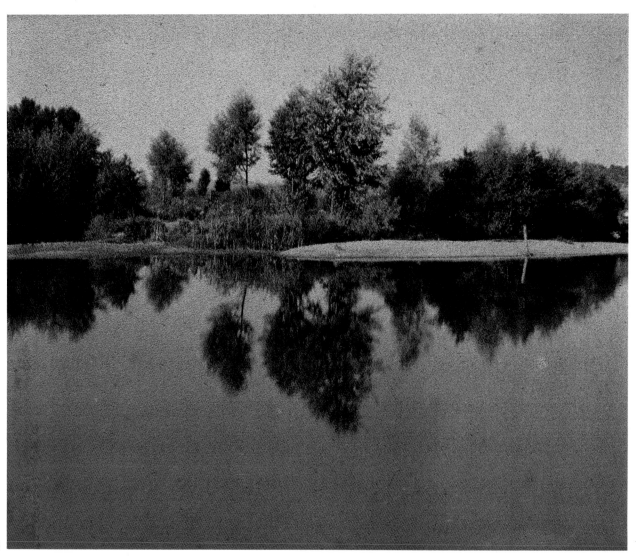

3

4. Allier River at Vichy, 1913.

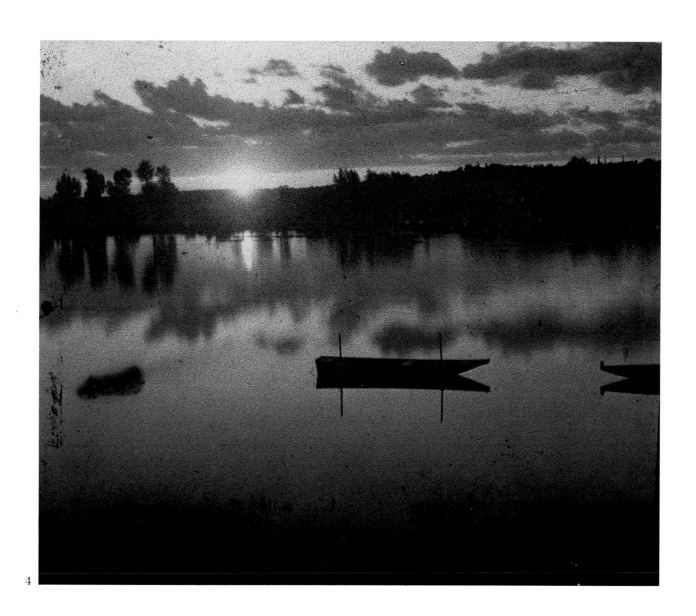

4

5. My friends and me in the Auvergne, 1913 (photo taken with my self-timer).

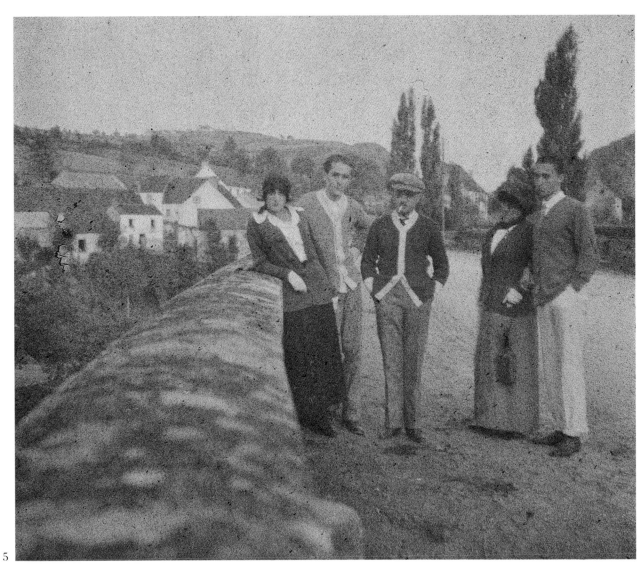

5

6. Fishing party in Rouzat, 1913 (taken with self-timer).

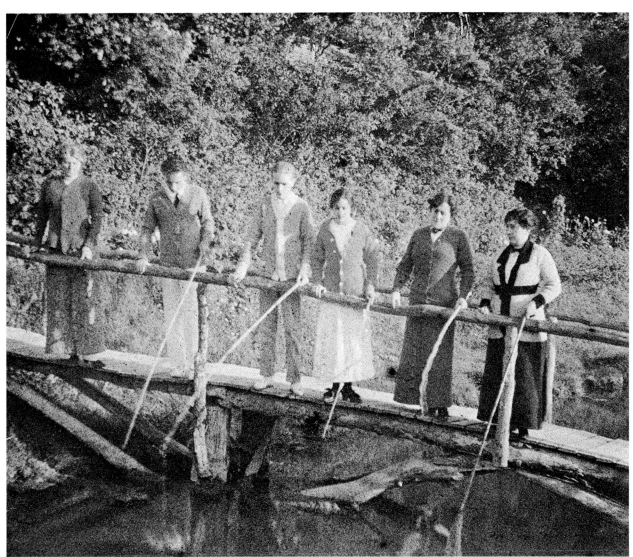

6

7. My two-wheeled "bob," Rouzat, 1913 (taken with self-timer).

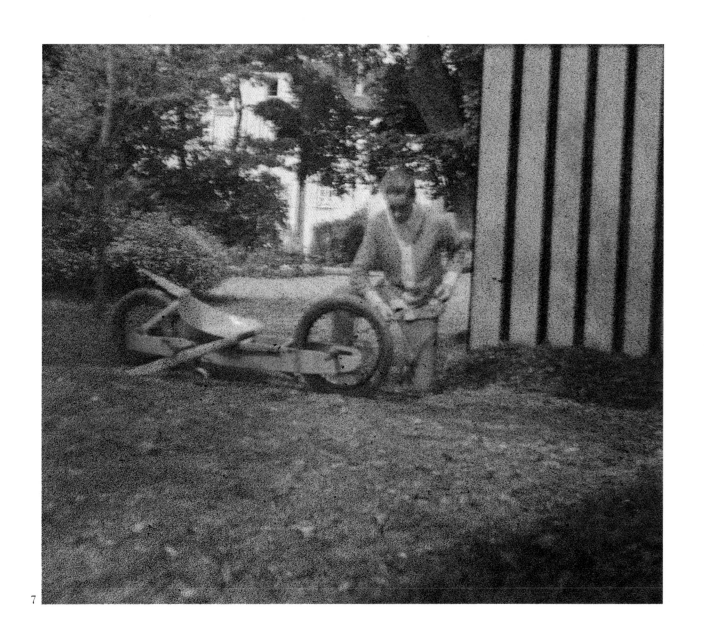

7

8. Simone Roussel sitting on my two-wheeled "bob," Rouzat, 1913 (taken with self-timer).

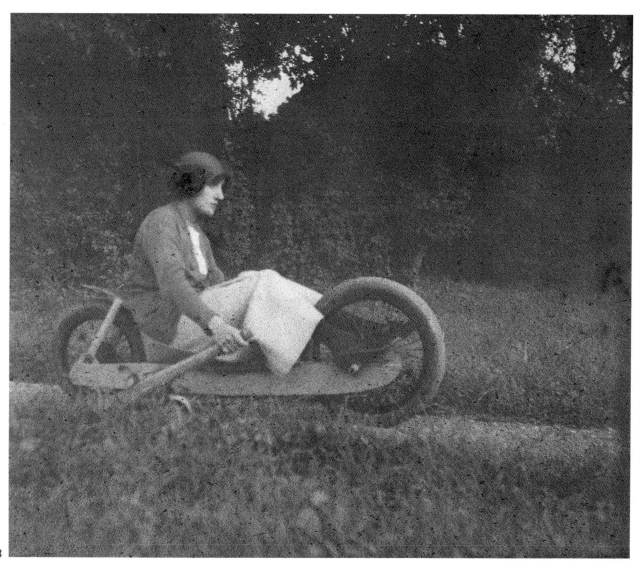

8

9. Airplane built by my brother Zissou, Rouzat, 1913.
From left to right: me, my brother, and a friend (taken with
self-timer).

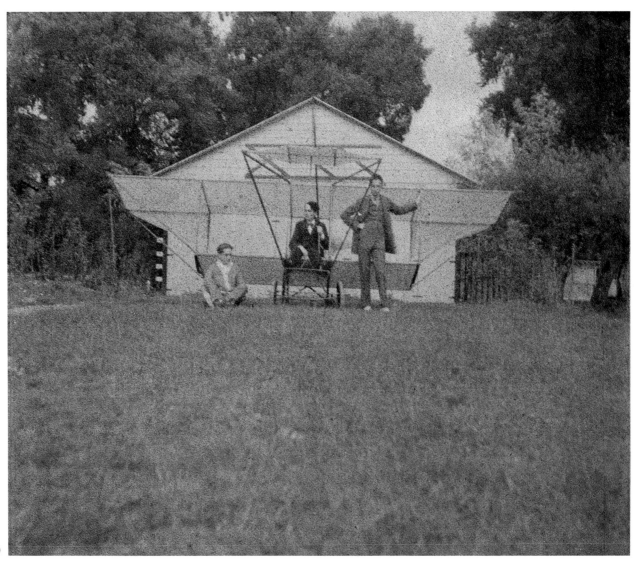

9

10. Practicing golf in a meadow, Rouzat, 1913 (taken with self-timer).

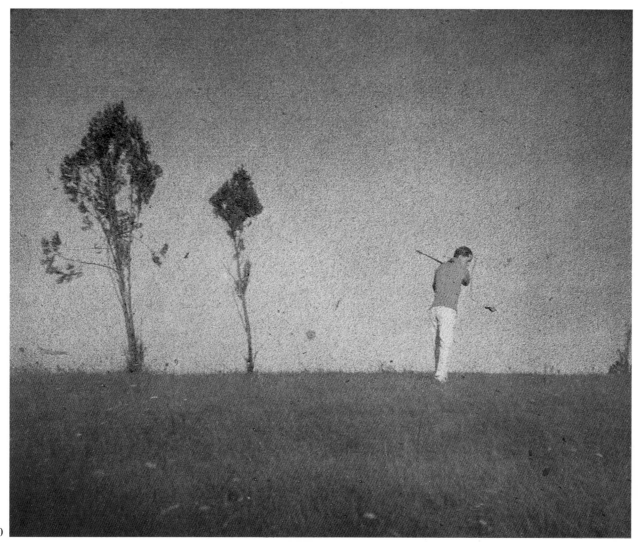

10

11. Mme. Charles Samuel in Rouzat, June 1914.

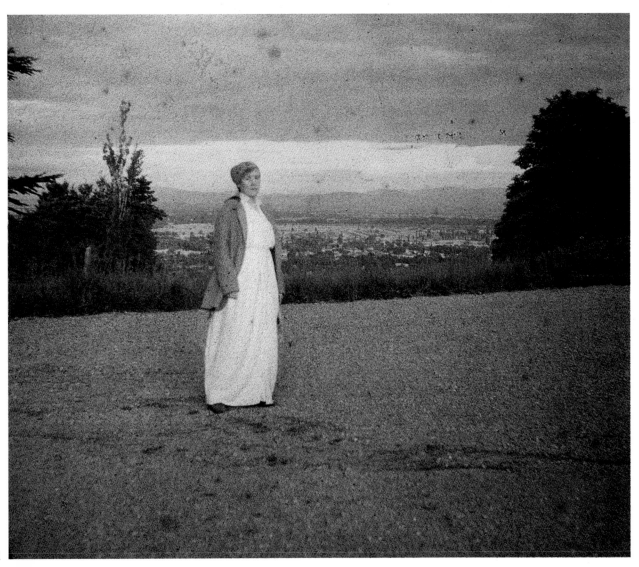

11

12. Chamonix, 1914.
From left to right: Francis Pigneron (French figure-skating
champion), me, Dr. André (a better doctor than skier),
Germaine Pigneron, Berg, Yvonne Bourgeois (sister of the
dress designer Madeleine de Rauch), and a skiing friend of
ours (taken with self-timer).

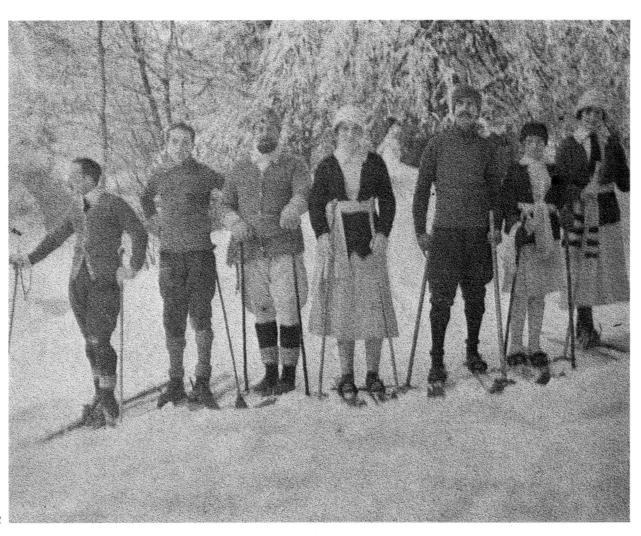

12

13. At Chamonix, 1914 (taken with self-timer).

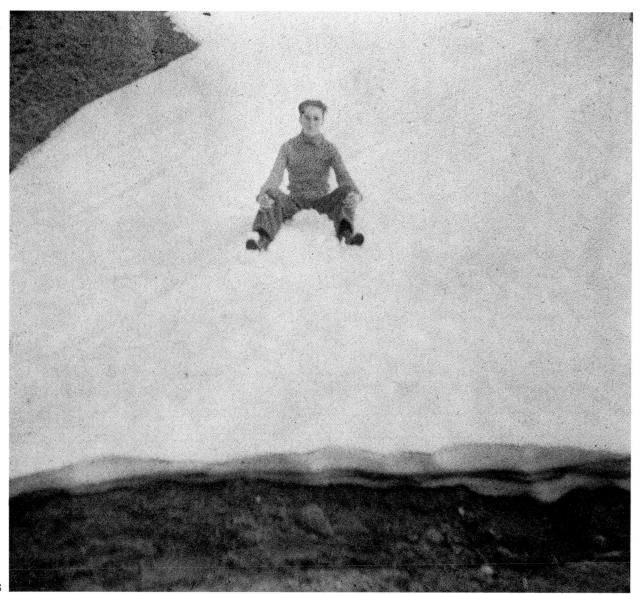

13

14. Arcachon, 1914.

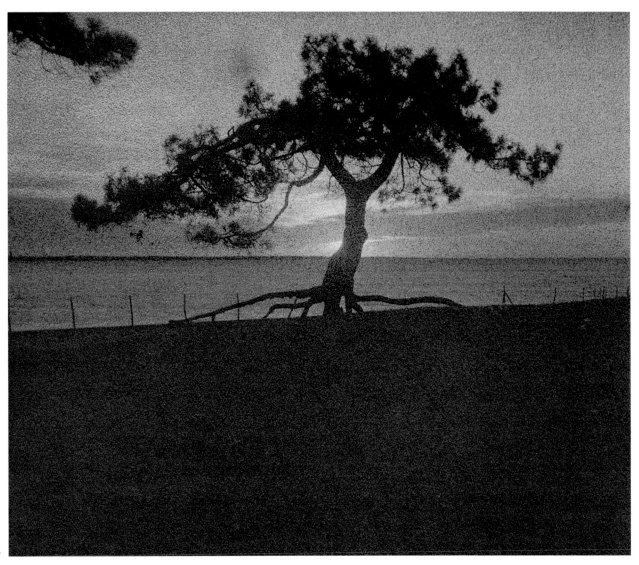

14

15. Paris, Avenue du Bois, 1915.
Lilian Mur, on the right, with a friend.

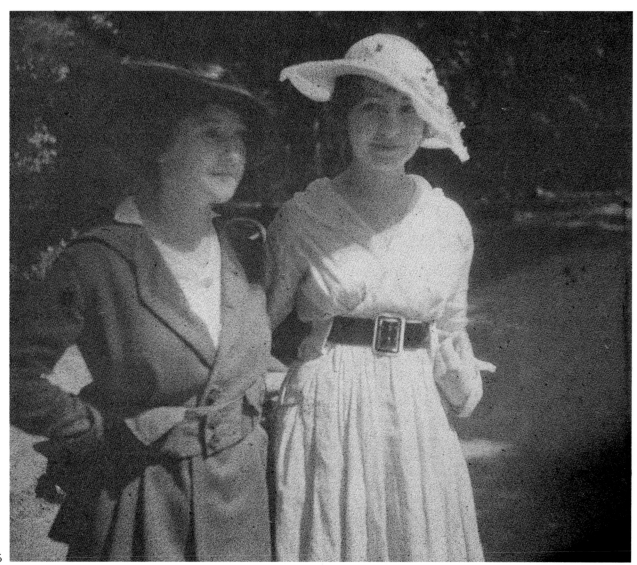

15

16. Bibi in Nice, 1920.

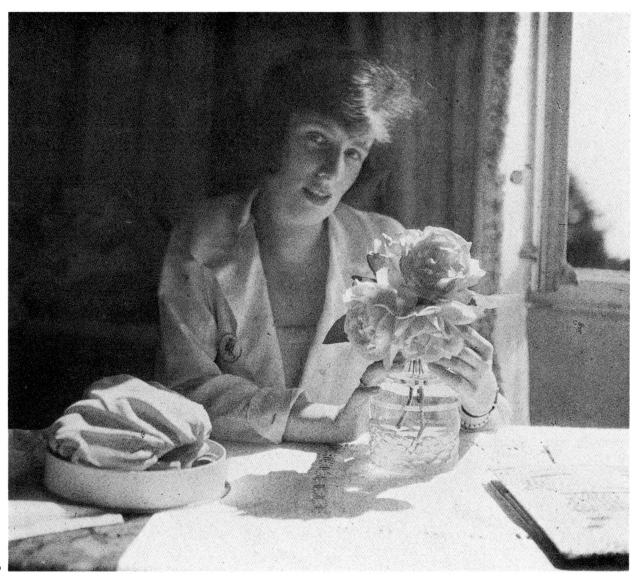

16

17. Bibi in the gardens of the Château de La Garoupe, Cap
d'Antibes, 1920.

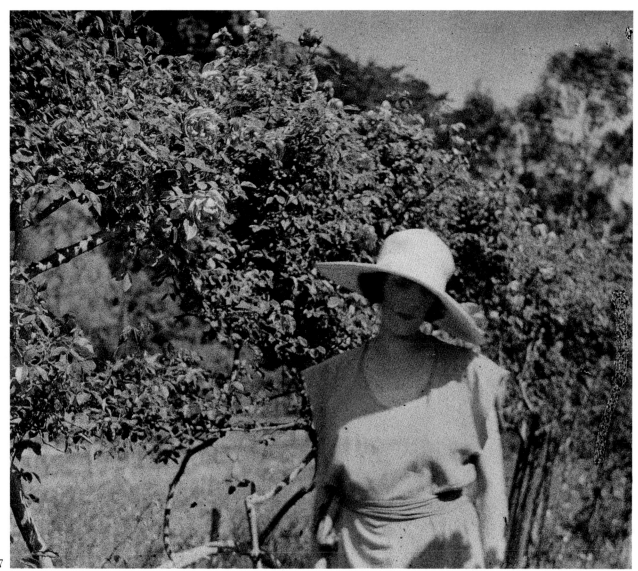

17

18. Bibi in the Eden Roc Restaurant, Cap d'Antibes, 1920.

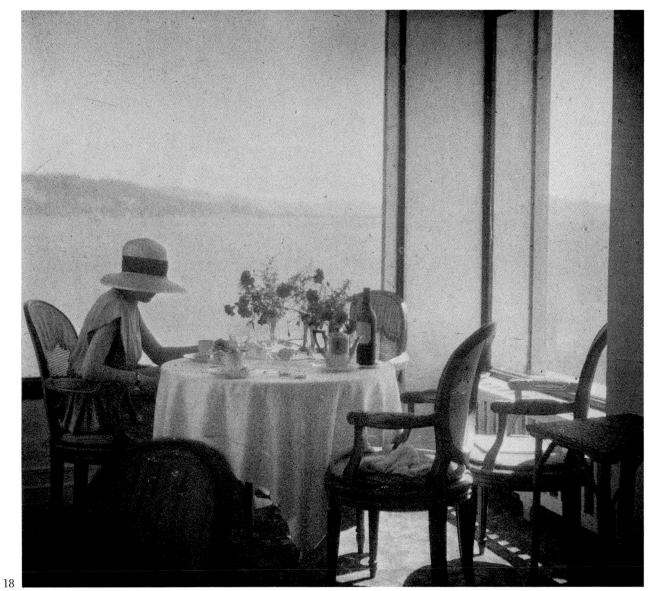

18

19. Bibi in Nice, 1920.

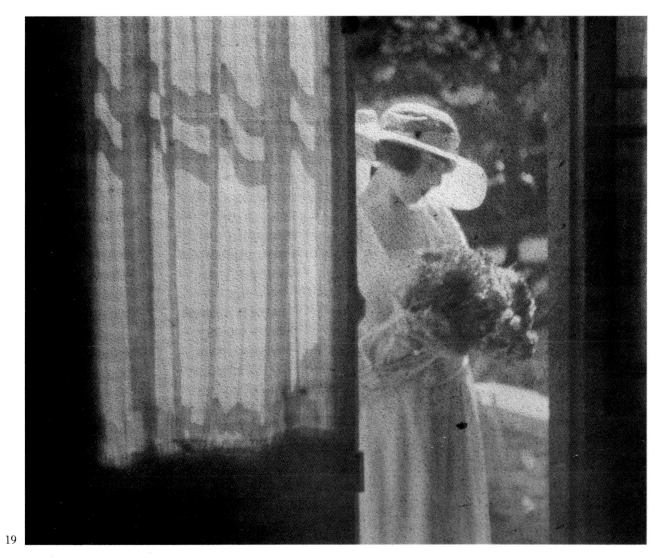

19

20. Bibi in Nice, 1921.

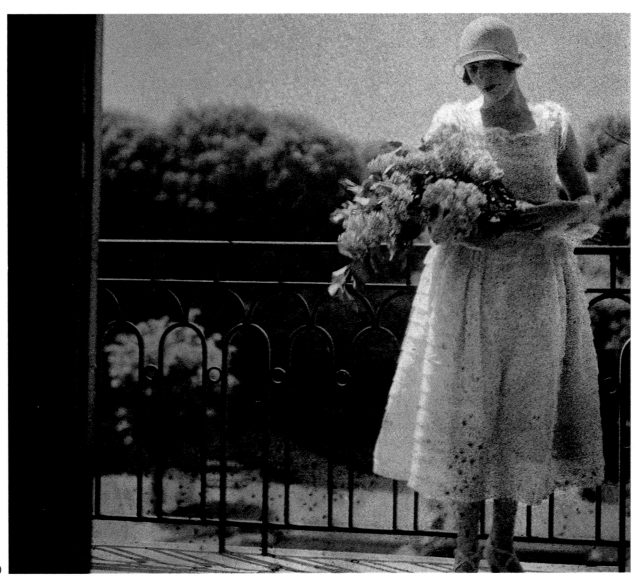

21. Bibi in Nice, 1921.

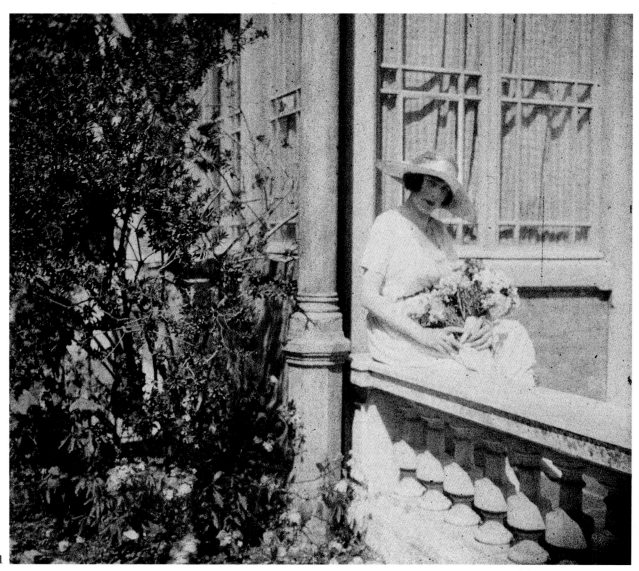

21

22. Bibi at the Château de La Garoupe, 1921.

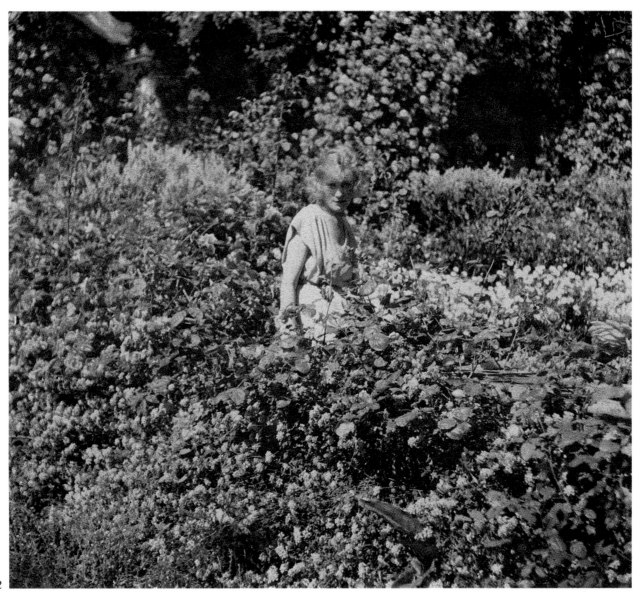

22

23. Bibi at the Château de La Garoupe, 1921.

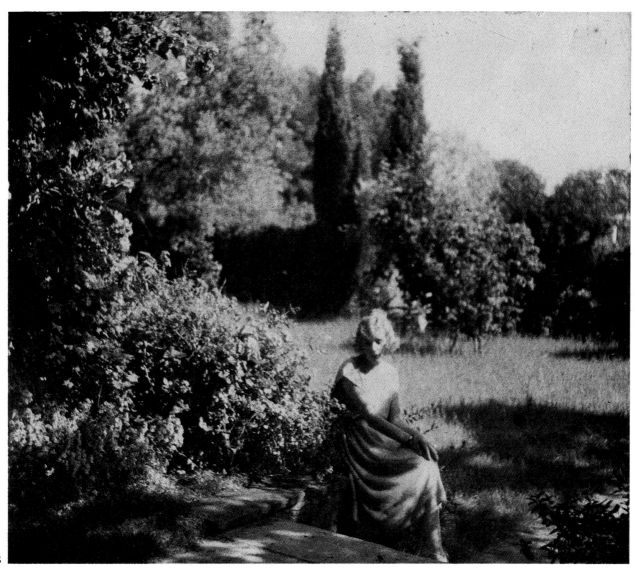

23

24. Bibi in Rouzat, 1921.

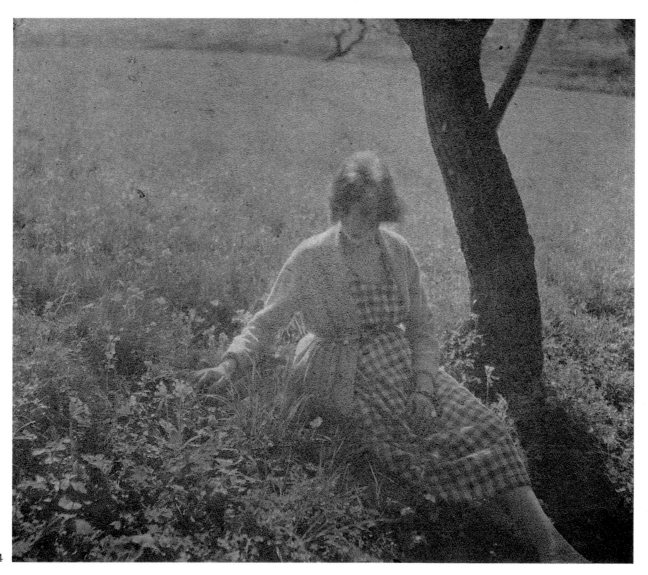

24

25. Bibi in Rouzat, 1921.

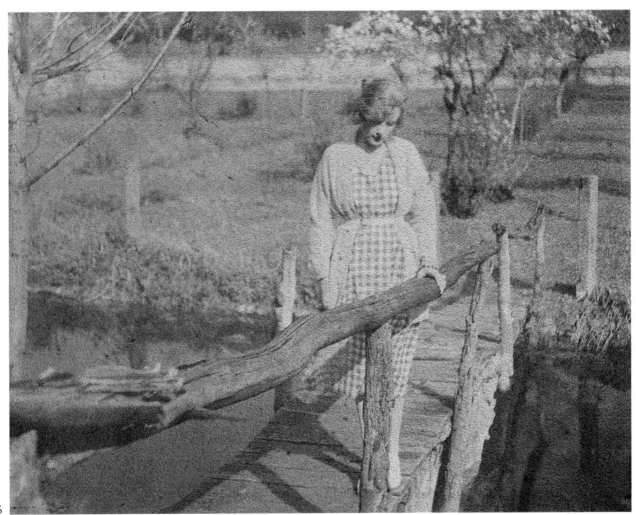

25

26. Bibi in Paris, 1921.

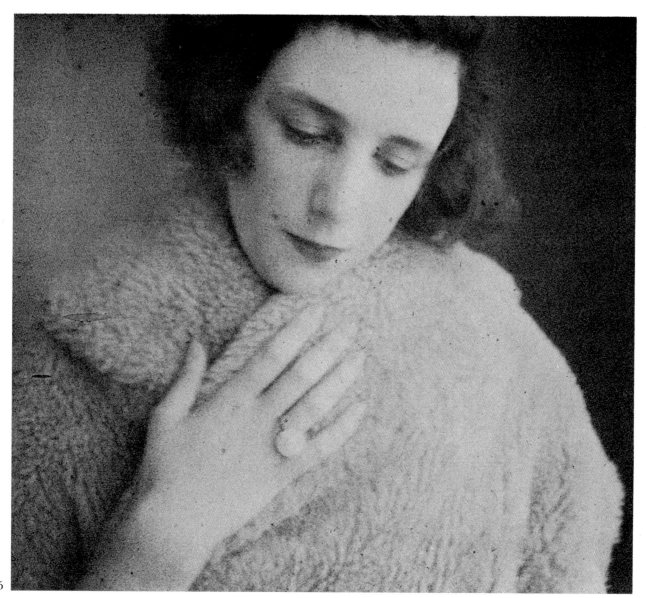

26

27. Paris, 1921.

27

28. Bibi at Cimiez, Nice, 1927.

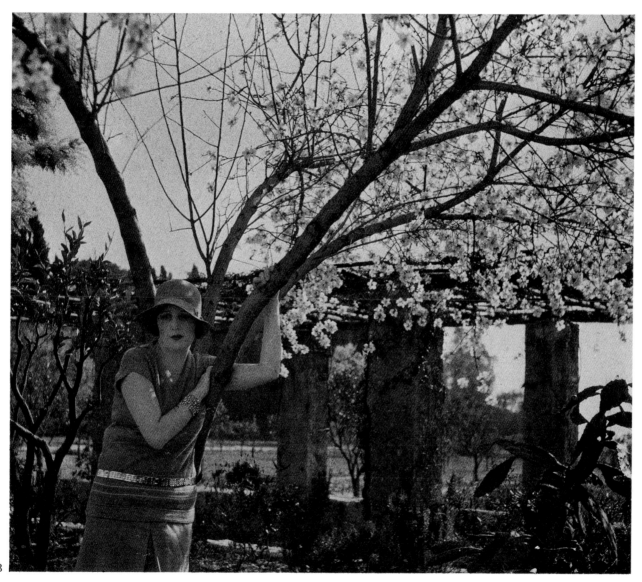

28

29. Hendaye, 1927.
On the left: Bibi. Then: Simone Berriau, a friend, Nana.
In front: my son Dani.

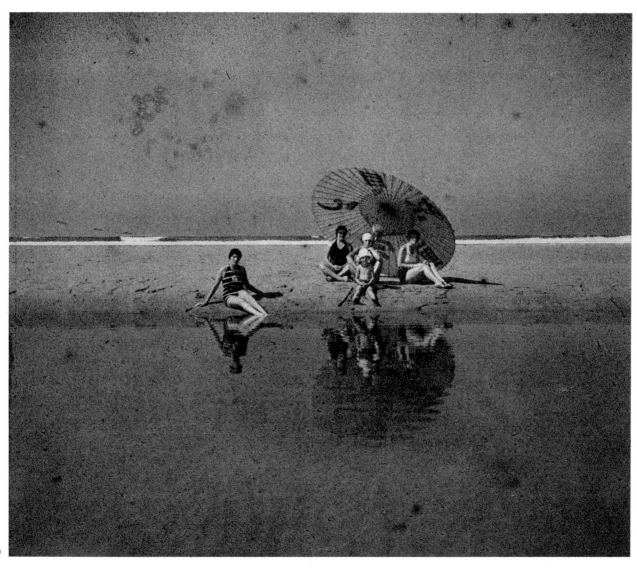

29

30. Bibi on the Île de Saint-Honorat, Cannes, 1927.

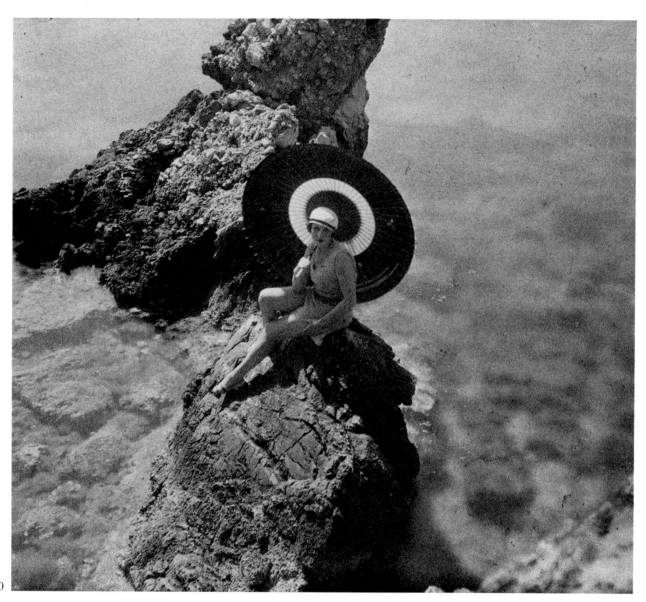

31. Arlette Boucard in Cannes, 1927.

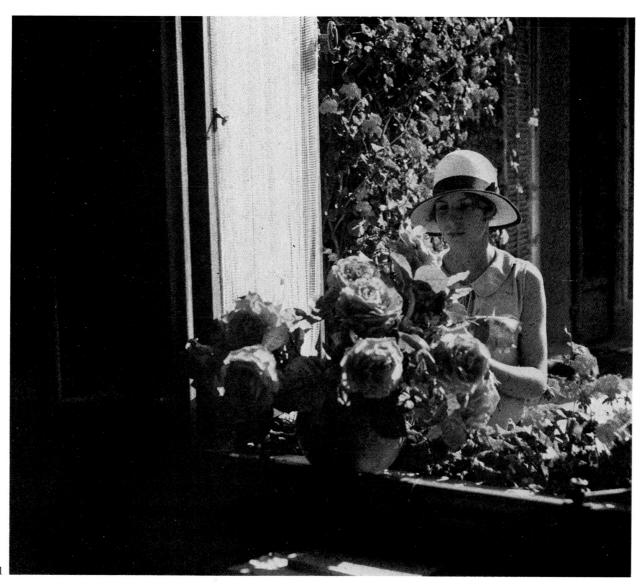

31

32. Lebanon, 1960.
This isn't an autochrome. But it is Florette. . . .

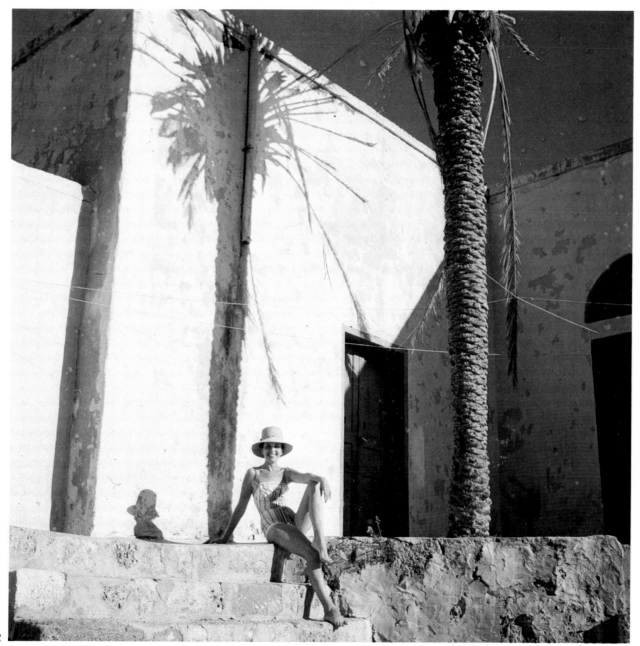